Alexandra Carron

A Beginner's Guide to Mosaics

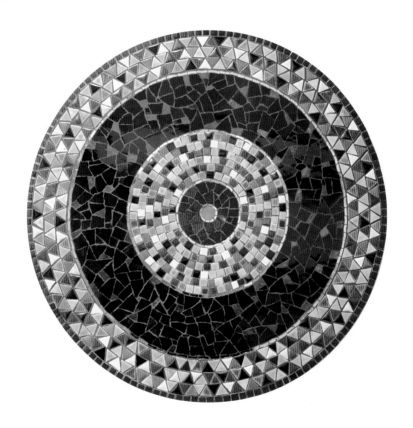

Four Decorative Projects

Schiffer Publishing Ltd

4880 Lower Valley Road · Atglen, Pennsylvania 19310

Schiffer Books are available at special discounts for bulk purchases for sales promotions or premiums. Special editions, including personalized covers, corporate imprints, and excerpts can be created in large quantities for special needs. For more information contact the publisher:

Published by Schiffer Publishing Ltd.
4880 Lower Valley Road
Atglen, PA 19310
Phone: (610) 593-1777; Fax: (610) 593-2002
E-mail: Info@schifferbooks.com

For the largest selection of fine reference books on this and related subjects, please visit our website at
www.schifferbooks.com
We are always looking for people to write books on new and related subjects. If you have an idea for a book, please contact us at
proposals@schifferbooks.com

This book may be purchased from the publisher.
Include $5.00 for shipping.
Please try your bookstore first.
You may write for a free catalog.

In Europe, Schiffer books are distributed by
Bushwood Books
6 Marksbury Ave.
Kew Gardens
Surrey TW9 4JF England
Phone: 44 (0) 20 8392 8585; Fax: 44 (0) 20 8392 9876
E-mail: info@bushwoodbooks.co.uk
Website: www.bushwoodbooks.co.uk

Library of Congress Control Number: 2012930639

ISBN: 978-0-7643-4096-3
Printed in China

I would like to thank:

❖ Helene and Olivier for their patience
❖ My students for their participation and good humor
❖ Patrice Magnard for so many things...

www.alexandracarron.fr

Editorial Director: Guillaume Pô

Editor: Hélène Raviart

Artistic Director: Laurent Quellet

Graphic design and layout: Julie Mathieu

Photographers: Franck Schmitt (pages 17, 23, 25, 33, 35,
43, 45, and 49)

and Olivier d'Huissier (all other photographs)

Contents

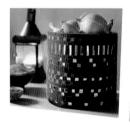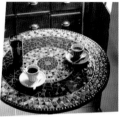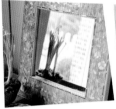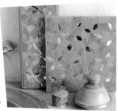

Preface

I have been a professional ceramist and mosaicist since 1997; I've been giving lessons in my Paris studio for some ten years now.

Mosaic craft is an easy way to create, giving amazing and encouraging results very quickly. So, as time goes by, my students become more and more bold and inventive.

Mosaics are a playful and varied art form: designs are limitless; nearly any material and any base may be used and combined.

Furthermore, you don't need to know how to draw to execute a project. Abstract compositions, unexpected designs – let your inspiration guide you and you'll develop a style of your own.

In this book, I offer four projects in varying styles, each of which presents different technical challenges. Going step by step, you will discover all the different techniques of cutting and placing and will become expert in handling the four primary tools.

This book is a handy tool for working with mosaics. And the introductory pages present all the information you'll need before you begin working.

I hope you will enjoy consulting this book as much as I enjoyed writing it.

Happy creating!

Alexandra Carron

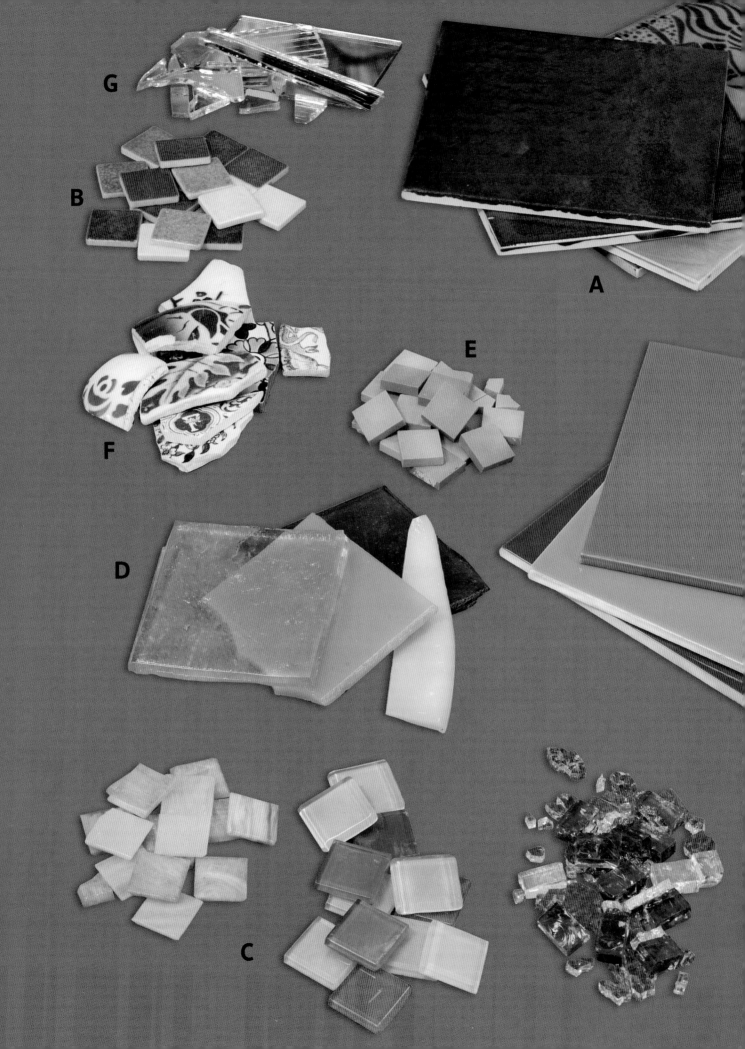

Before you begin

MATERIALS

There is an enormous variety of materials from which mosaics can be made.

The most common are ceramic, glass, and porcelain tiles, sold in DIY stores or specialized outlets. Anything may be used and recycled: beads, marbles, plastic, metal, shells… All these materials may be combined and used in the same mosaic. It is easier, however, to combine materials that have the same thickness.

Ceramic (A)

Ceramic comes in 5 $\frac{7}{8}$" x 5 $\frac{7}{8}$" (15cm x 15cm) tiles, $\frac{1}{4}$" (5mm) thick. They may be industrial or handmade. Ceramic cuts easily with a tile nipper. It is not frost-resistant, so it is not recommended for outside use.

Porcelain (B)

Porcelain comes in $\frac{7}{8}$" x $\frac{7}{8}$" (2.3cm x 2.3cm) tiles, $\frac{1}{8}$" (3mm) thick. Shock-resistant and adaptable to a wide range of temperatures, these tiles can be exposed to freezing temperatures.

Industrial glass (C)

Industrial glass comes in $\frac{5}{8}$" x $\frac{5}{8}$" (1.5cm x 1.5cm) tiles, $\frac{1}{8}$" (3mm) thick. The tiles are smooth on top and ridged underneath so they'll stick better. Industrial glass tile generally can be exposed to freezing temperatures.

Handmade glass tiles (D)

Handmade glass comes in 3 $\frac{1}{8}$" x 3 $\frac{1}{8}$" (8cm x 8cm) tiles, $\frac{1}{4}$" (0.5cm) thick. There are more than 200 colors, opaque or transparent. Handmade glass is not frost-resistant.

Stoneware (E)

Stoneware comes in $\frac{5}{8}$" x $\frac{5}{8}$" (1.5cm x 1.5cm) tiles, $\frac{1}{8}$" (3mm) thick. Colors range from browns to pastels. The finish is matt. Stoneware is shock-resistant and adaptable to a wide range of temperatures. It is frost-resistant.

Dishware (pottery, porcelain, or stoneware) (F)

Broken dishes may be used in mosaics. If the pieces are not flat, they must be glued with thinset mortar (see Adhesives, page 14). Ceramic and porcelain dishware are not frost-resistant, unlike stoneware.

Mirror (G)

Pieces of mirror may be used to add touches of sparkle and light to your mosaics. Mirror is frost-resistant.

TOOLS

COMPRESSION TOOLS

Tile nipper (A)
This is the tool used to cut ceramic (tiles or dishware). It is ideal for cutting, trimming, and shaping. The nipper may also be used to cut stoneware. It should not be used to cut mirror (shards may go flying).

Mosaic glass cutter (B)
This tool is perfect for porcelain tiles, glass tile, stoneware, and mirror. It cuts more cleanly, without crushing, so can be used more accurately.

OTHER CUTTING TOOLS

Tile scorer (C) and Glass cutter (D)
These tools are indispensable when you need to cut geometric shapes, long straight lines, or curves. They suit all types of material.

CAUTION
Wear safety glasses when cutting mosaic materials to protect your eyes from flying shards.

ASSORTED SUPPLIES
Besides the materials mentioned above, you will need a certain number of tools to make your mosaic:
- Pencil, eraser, ballpoint pen, felt-tip pen
- Paper, tracing paper, carbon paper, and tape for tracing the design
- Ruler and drawing square
- Brush for glue
- Small knife to apply or remove cement precisely
- Containers for glue, cement, and grout
- Fiberglass mesh
- Gloves, cloths, and safety glasses

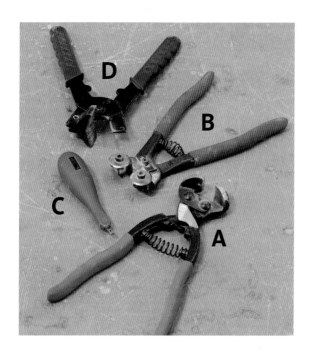

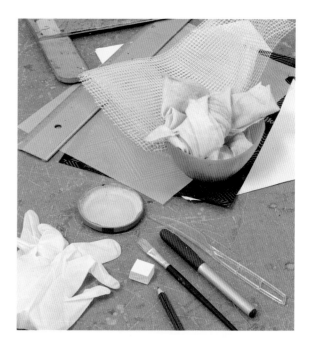

CUTTING TECHNIQUES

CUTTING CERAMIC WITH
THE TILE NIPPER

Irregular Shapes

1. Position the nipper against the edge of the tile; open it so the tile is halfway inside the nipper's mouth, at a slight angle.

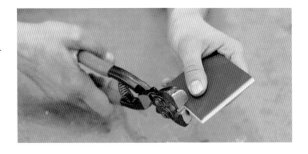

2. Put your thumb across the cutting line, then close the nipper. This positioning lets you hold on to both pieces.

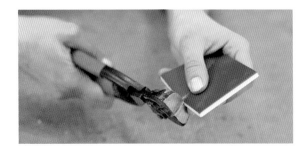

3. Repeat until you have the shape you want.

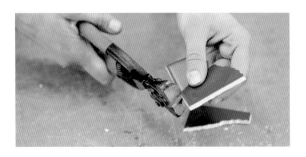

Triangular shapes

1. Position the nipper, this time not at the edge of the tile, but directly on top of it.

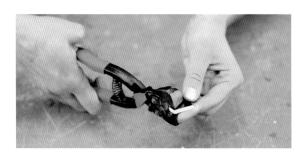

2. Close the nipper.

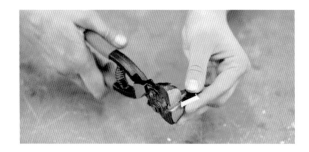

Rounded shapes

To cut out a round shape, you can either draw a circle with a felt-tip pen on the tile or cut free-form.

With the tip of the nipper, nibble carefully along the edge of the circle.

Cutting stoneware or glass tile with the mosaic glass cutter

Irregular shapes

1. Position the cutter in the middle of the tile, on the bias, keeping the blade perpendicular to the tile.

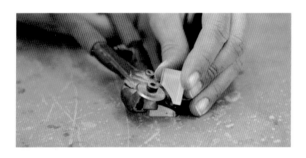

2. Always keep the piece to be cut out towards the table.

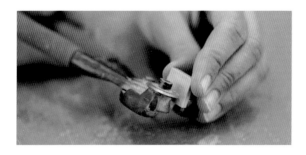

Flame shapes

1. Position the cutter in the middle of the tile, parallel to the edge.

2. Close the cutter: The narrow pieces will automatically curve out in the middle.

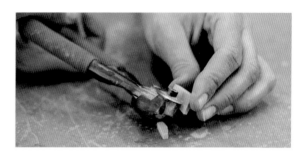

Squares

1. Position the cutter in the middle of the tile, parallel to the edge.

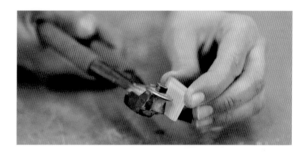

2. Close the cutter to make two rectangles.

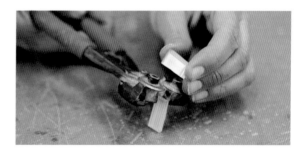

3. Cut each rectangle in two the same way.

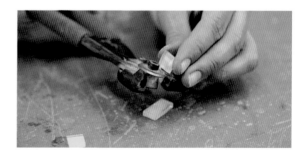

Concave shapes

1. Position the cutter close to the edge.

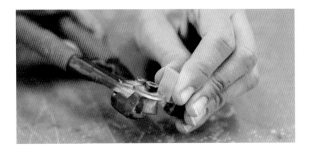

2. If necessary, accentuate the hollow by nibbling delicately at the center of the curve.

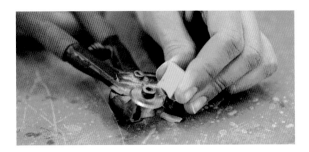

CUTTING WITH THE TILE SCORER AND GLASS CUTTER

Rectangles

1. Mark cutting points with a felt-tip pen on one edge.

2. Position the drawing square on the edge of the tile. Trace the lines with the tile scorer in a firm, continuous motion.

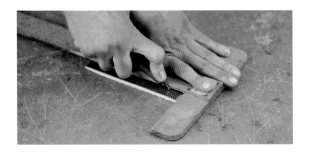

3. Cut the strips in pairs; they will be less fragile. To do this, put the glass cutter on the edge of the tile, centered on the outside line.

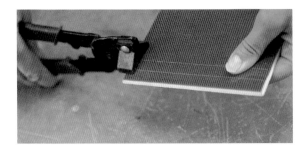

4. Press down gently, keeping the thumb across the cutting line.

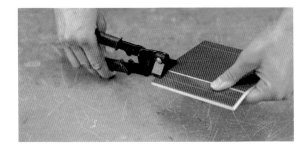

5. Separate the pair.

Curving strips

1. Trace the curves with the tile scorer from bottom to top.

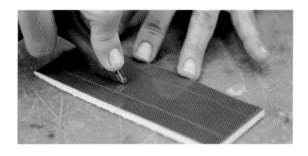

2. Separate them by pairs, pressing the glass cutter down as gently as possible and positioning your thumb across the cutting line.

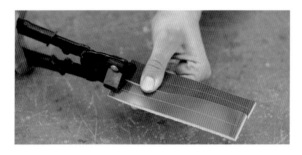

Squares

1. Cut two strips as wide as the desired square. Don't separate them.

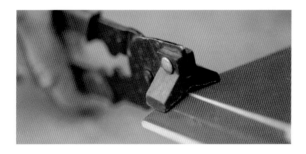

2. Using the tile scorer, trace lines across the width of these strips.

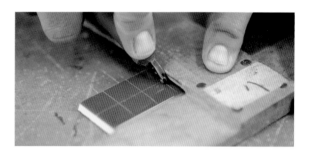

3. Separate the pair of strips.

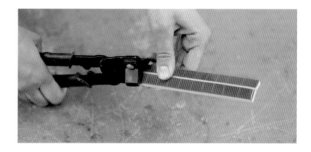

4. Separate the squares.

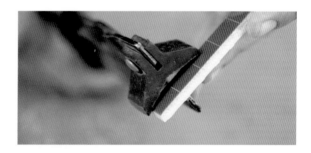

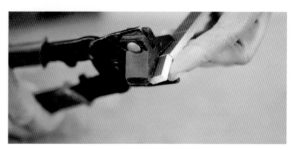

PREPARING YOUR SURFACE

Mosaics can be applied to all kinds of surfaces: walls, floors, flat or three-dimensional decorative objects, furniture, etc. The important thing is to prepare your surface well and to choose the appropriate adhesive.

WOOD

Use wood treated for water-resistance. For indoors, use waterproof particleboard. For outdoors, use marine plywood.

Score the wood lightly with a utility knife to ensure optimal adhesive binding. Strip varnished or painted furniture before covering it with mosaic. Since this is a time-consuming operation, if the varnish or paint seems to be in good condition (check by scraping); you may opt simply to sand lightly and apply a bonding primer.

When wood is stripped, it must be protected against the moisture of the glue and grout: Apply a filler that will preserve a slight porosity so glue and grout adhere, but don't penetrate.

WALLS

If your wall is painted and in good condition, simply apply bonding primer. If you need to strip the wall (obligatory for a mosaic larger than 39 ½" x 39 ½" (1m x 1m), plaster it smooth and apply a bonding primer.

TILE FLOOR

It is possible to apply mosaic over a tile floor; cover it with bonding primer first. Don't worry about the gaps between the tiles: the mortar will fill them and eliminate any risk of unevenness.

EARTHENWARE POTS

If the outside of the pot isn't glazed, the mosaic must be protected from moisture by applying spar varnish to the entire inside surface. The mosaic may then be glued directly to the earthenware.

OTHER SURFACES

It is also possible to apply mosaics to glass and other materials. This doesn't require any particular treatment of the surface, but simply the use of special adhesives.

TRACING A DESIGN

1. Trace the selected design onto white paper. Tape the paper to the surface.

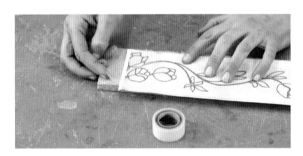

2. Slide a sheet of carbon paper under the white paper.

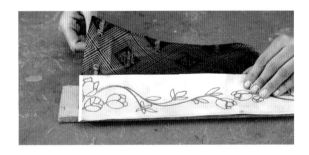

3. Go over the design with a ballpoint pen.

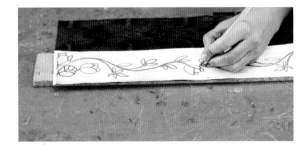

ADHESIVES

Adhesives must be appropriate for both the surface and the materials used. It is important to choose your adhesive well, because mosaics may come unglued several months after application. All the adhesives described here may be found easily in DIY stores or specialized outlets. Product quality may vary considerably depending on the manufacturer. Read the instructions first to confirm for what surfaces the adhesive is suited and for what type of exposure (indoor or outdoor).

INDOOR EXPOSURE

On wood, use white PVA glue or slow-drying wood glue (A). Apply the glue directly to the wood with a small brush.

For floors, walls, earthenware, or porcelain, use ready-to-use thinset mortar (B). This is a sticky mixture applied with a small knife or spatula directly on the surface. It is sold in cans, generally from 2 lb., 3oz. to 11 lb. (1 to 5kg). Count on approximately 6 lbs., 10 oz. (3kg) per 39 ½" x 39 ½" (1m x 1m).

For floors, walls, and objects in earthenware only, it is also possible to use tiling mortar (C), which is less expensive than thinset mortar.

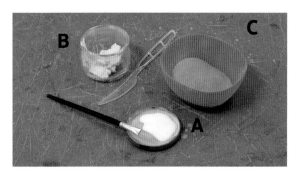

OUTDOOR EXPOSURE

On concrete, cement, plaster, or earthenware, use powdered tiling mortar formulated for outdoor use. Mix this powder with water in a bucket until you have a fairly thick consistency, not too liquid, with no lumps. This type of mortar is generally recommended for variations in temperature and is frost-resistant. Once again, be sure to check the instructions. Not all tiling mortar is frost-resistant!

CAUTION
Wear latex gloves; mortar is bad for the skin.

THE DIFFERENT TYPES OF MOSAIC CONSTRUCTION

The **direct method** consists of applying the mosaic directly to the surface. This is the method used for three of the projects in this work: the vase, the mirror, and the table.

The **indirect method** consists of first gluing the mosaic on paper or fiberglass mesh. Then the whole design is applied to the desired surface. This is the method used for the frosted decoration. The indirect method is generally used for mural or floor mosaics. It allows you to work comfortably at a table, for a faster, better-controlled project.

GROUT

Grout comes in powder form. It binds, consolidates, and unifies your work; it is the final touch. Your choice of grout color is very important. A bad choice can ruin your work. In case of doubt, make some color tests beforehand on small areas. Generally speaking, dark grout (dark gray or black) is best if the mosaic is brightly colored. Contrasts and patterns will be highlighted. Use light-colored grout if your mosaic is mostly white or pastel. You can use different grout colors in the same mosaic.

There is grout for indoor or outdoor use in different colors. White grout can be tinted with dyes or acrylic paint (10% maximum of paint to the volume of prepared grout).

Preparation

1. Mix the grout powder with water. The texture should be thick. Once prepared, grout remains usable for about an hour.

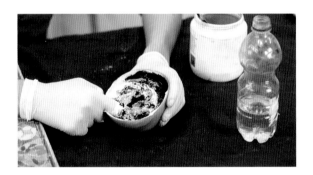

2. With your (gloved) hand, apply the mixture generously, filling all the interstices well. Remove the excess by hand to allow even drying.

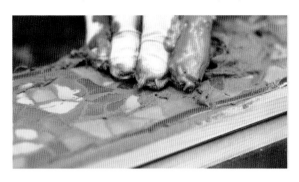

3. Five to fifteen minutes later, rub with a dry cloth to remove excess grout. If the grout is too dry to be removed, wet the cloth or use a damp sponge. If the grout sinks into the cracks, it's still too early to use the cloth. Wait a few minutes and fill in with more grout if necessary.

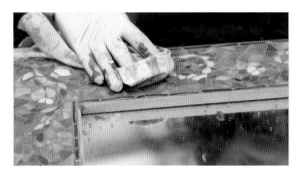

Ethnic vase

The matt finish of the stoneware combined with the ochres and warm browns give this piece a natural feeling that recalls traditional craftsmanship. By contrast, the glass tile highlights the mosaic and emphasizes the bold linearity of the design.

Materials

- Brown and ochre stoneware tiles
- Champagne-colored glass tile
- Mirror
- Earthenware pot

Tools

- Mosaic glass cutter
- Tile scorer
- Glass cutter
- Ruler
- Pencil
- Felt-tip pen
- Plastic knife
- Utility knife blade
- Sponge
- Cloth
- Assorted containers
- Latex gloves

Adhesives

- Black and brown grout
- Tiling mortar or thinset mortar

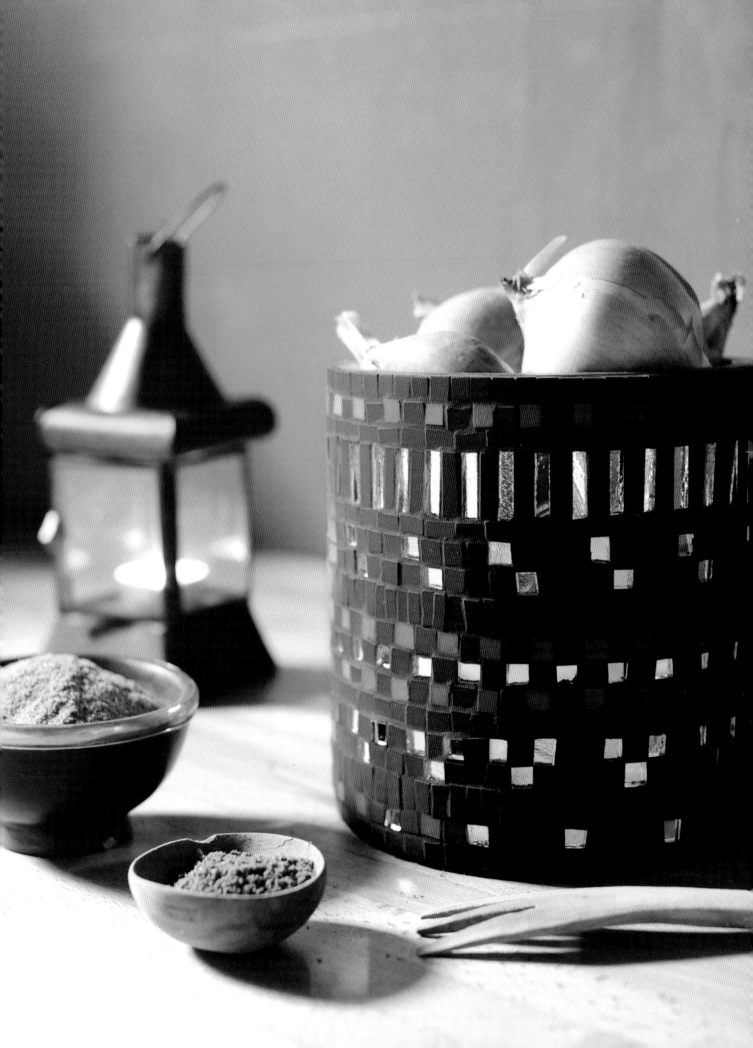

1 Lay out your design on a surface where length is equal to the height of the pot. Take into account the interstices between the tesserae: here, the design is ¼ inch (.5cm) shorter than the total height of the vase.

2 The design is made up of horizontal bands. Measure each one and trace it in pencil on the pot.

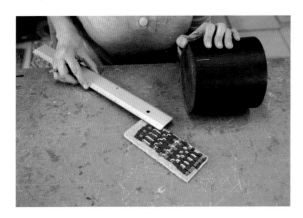

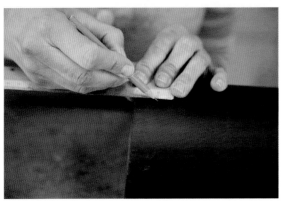

3 These guidelines guarantee an even design.

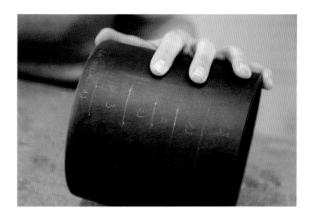

4 To get rectangular glass tesserae, mark guidelines with a felt-tip pen.

5 Trace lines from bottom to top with a tile scorer.

6 Using the glass cutter, cut strips two by two, then separate the pairs.

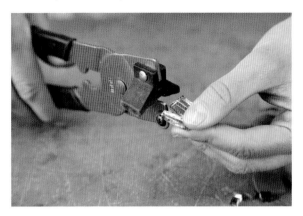

7 To get little squares, cut the strips with the mosaic glass cutter.

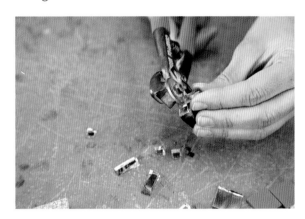

8 Cut the stoneware tiles into rectangles.

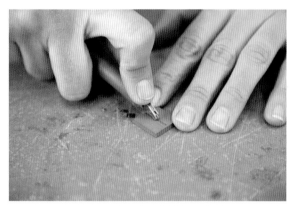

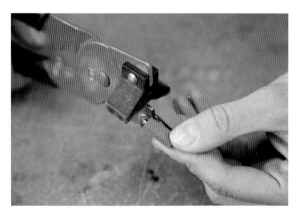

9 You can get smaller tesserae by cutting the rectangles again with the mosaic glass cutter.

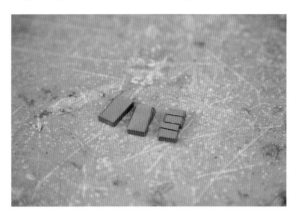

10 Using a plastic knife, apply thinset mortar or tiling mortar on the lower edge of the pot and apply the first row of tesserae, aligning them carefully. Remove excess mortar as you go, before it dries.

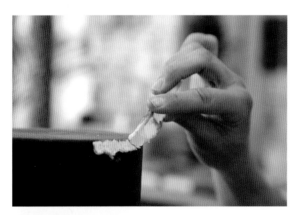

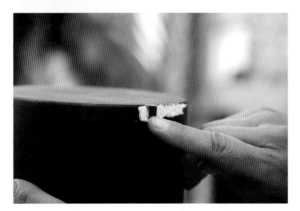

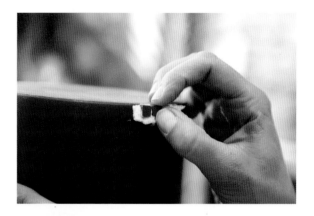

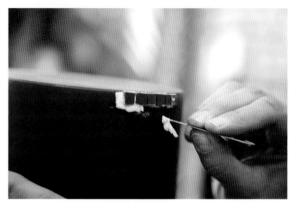

11 Repeat the procedure on the upper edge of the pot. Let dry.

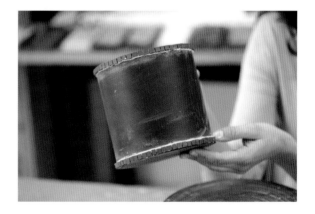

12 Continue applying tesserae line by line, following the penciled guidelines.

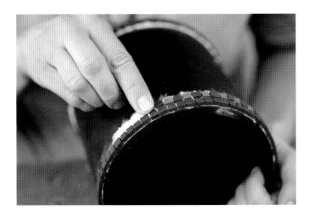

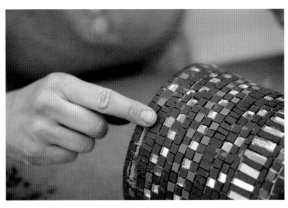

13 Mix brown and black grout to get a very dark brown.

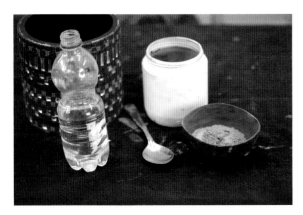

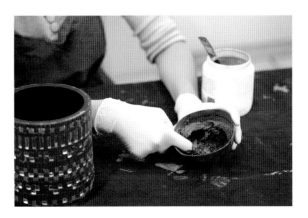

14 Apply the grout, making sure not to miss the interstices between the tesserae and the edges of the pot.

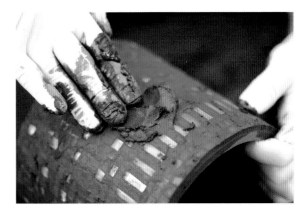

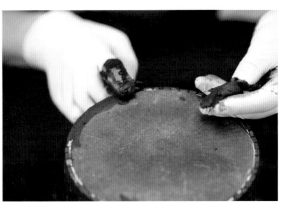

15 Rub with a dry cloth.

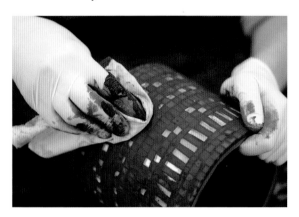

16 Since stoneware is slightly porous, it may be discolored by the grout. When the latter is dry, clean the mosaic with a sponge moistened with water or glass-cleaner.

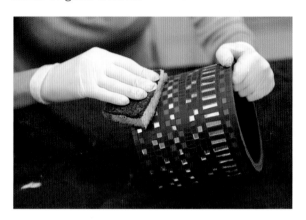

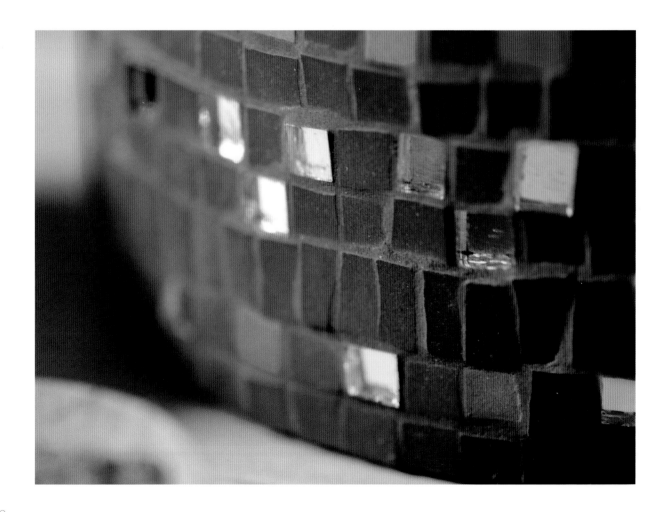

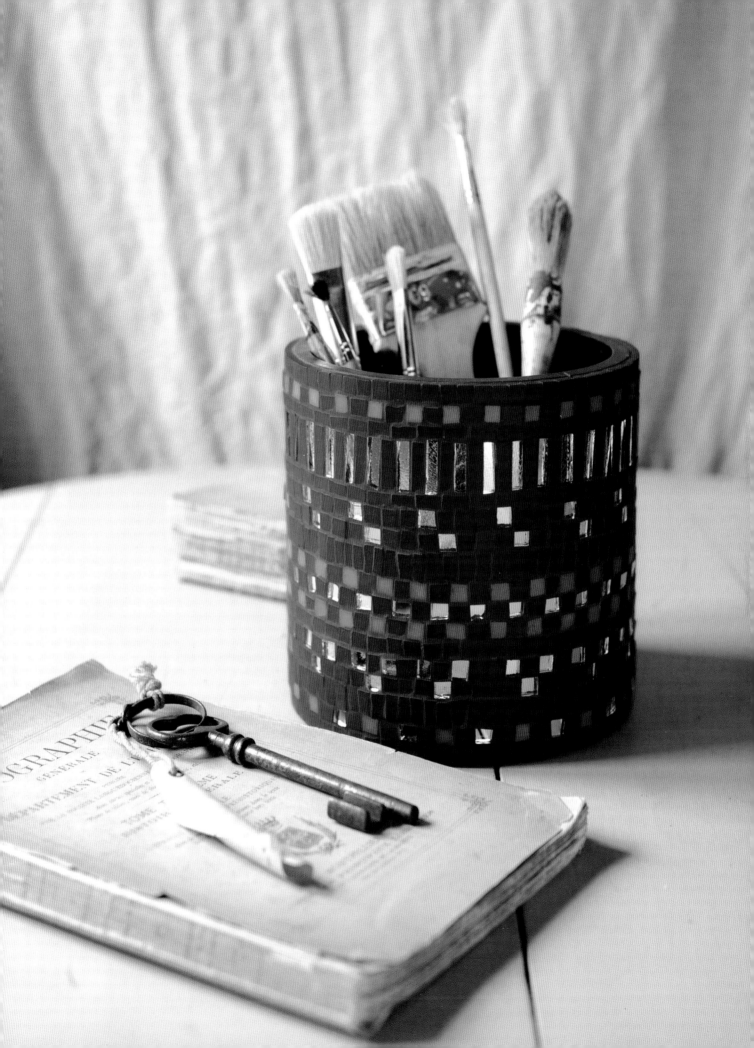

A colorful table

The dynamism of this composition derives from contrast: dark, irregular tesserae come up against multi-colored geometric patterns, black grout makes bright colors pop – a rousing design statement!

Materials

- Bright-colored and brown ceramic tile
- Mirror
- Disc of waterproof particleboard 23 ⅝" (60cm) in diameter

Tools

- Tile nipper
- Mosaic glass cutter
- Tile scorer
- Glass cutter
- Tape measure
- Ruler
- Pencil
- Felt-tip pen
- Brush for glue
- Cloth
- Assorted containers
- Latex gloves

Adhesives

- Wood glue
- Black grout

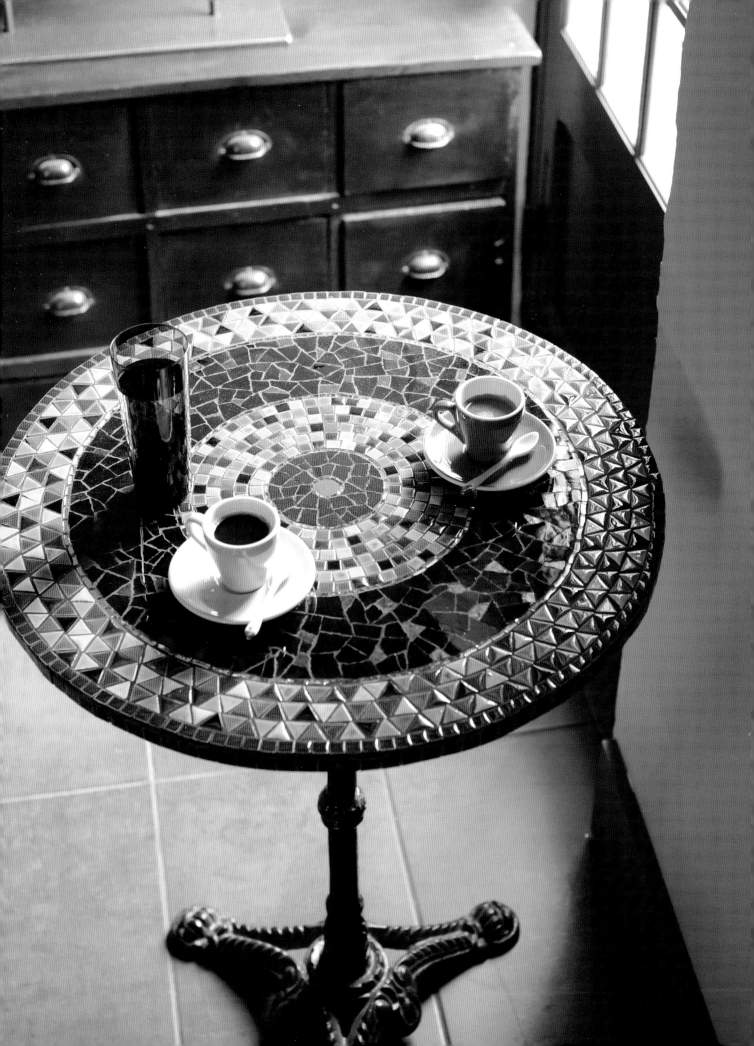

1 Using a tape measure, find the center of the disc.

2 Using a ruler, trace guide points on the axes of the disc: They will mark the width of the circles.

3 Join the guide points with a penciled line to form the circles of the design. Trace over the penciled line with a felt-tip pen.

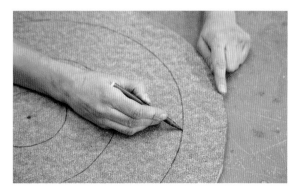

NOTE:
If you have a big compass, you can draw the circles of the design directly.

4 To get square tesserae, draw regularly spaced guide points on the two sides of a ceramic tile. These two sides should form a right angle.

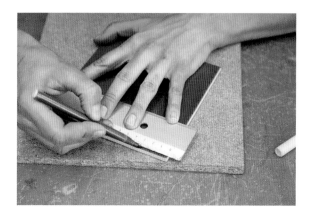

5 Draw horizontal and vertical lines, using these guide points, with the tile scorer.

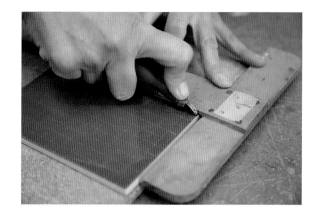

6 First split the tile into long rectangles made of two strips.

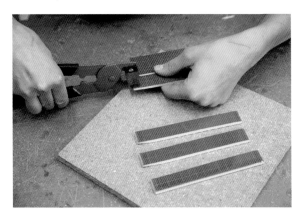

7 Recut each rectangle in two lengthwise, then separate the pairs.

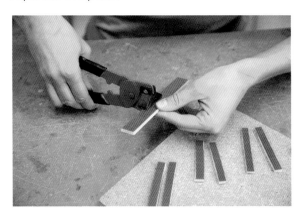

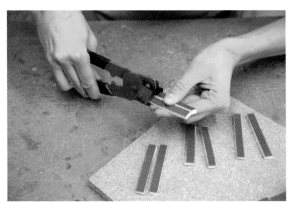

8 Cut the resulting strips into little squares.

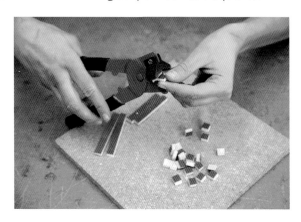

9 To get triangular tesserae, draw guide points with a felt-tip pen on a strip of ceramic: Regularly spaced, these points indicate the base and the summit of the triangles.

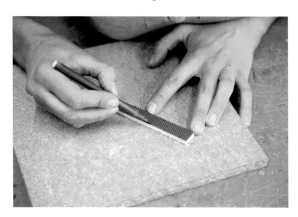

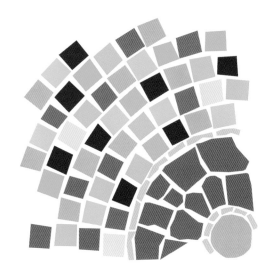

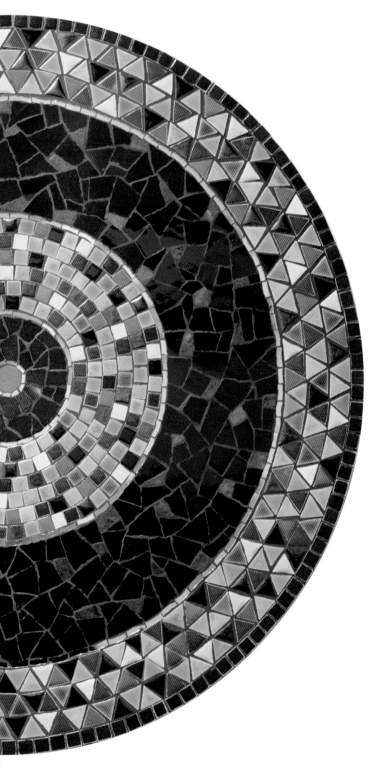

10 Trace from one point to the next with the tile scorer, going from bottom to top.

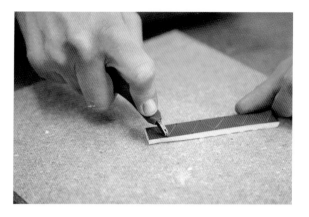

11 Following the line, cut out the triangles with the glass cutter.

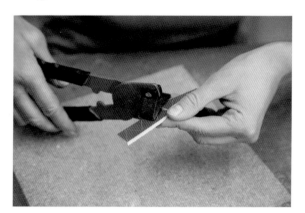

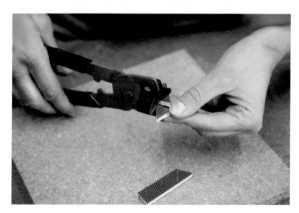

12 Narrowing tesserae of the mirror will form a border around the ceramic circles. To make this border, trace strips about ⅜ inch (1cm) wide with the tile scorer.

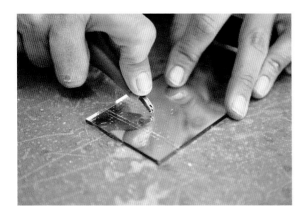

13 Separate the strips by pairs, then one by one.

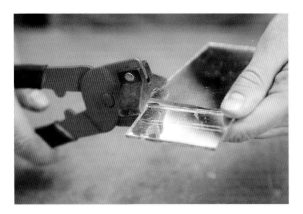

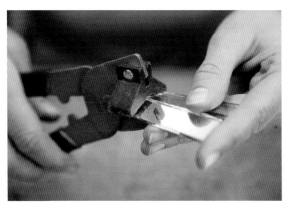

14 Using the mosaic glass cutter, cut the resulting rectangles into tiny tesserae. The smaller these are, the more curved they will be, which will better allow them to follow the shape of the circles.

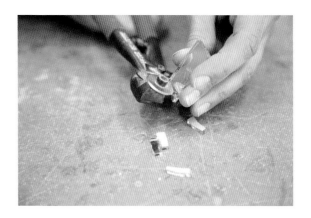

15 Using wood glue, apply tesserae to the side of the disc. Be careful that they don't go higher than the top surface of the disc and that they are well-aligned on the bottom.

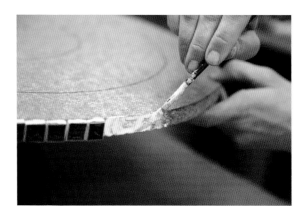

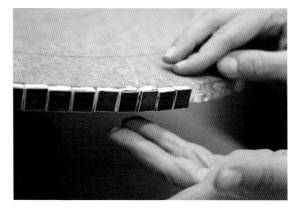

16 Next, apply the tesserae to the outer edge of the disc surface. Align them carefully and make sure they cover the tesserae on the side.

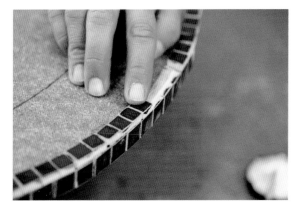

17 Glue the mirror tesserae along the circles you've drawn.

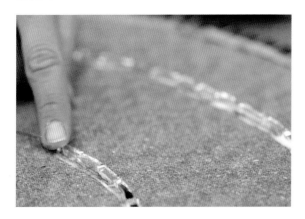

18 Fill in the first ring: Glue the square tesserae, row by row, starting with the outer row.

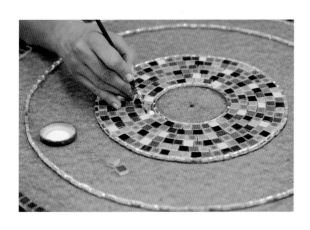

19 If necessary, recut a few tesserae on the bias with the mosaic glass cutter to fill open spaces.

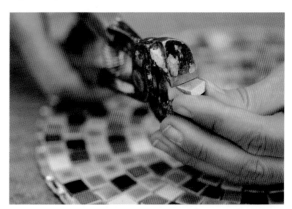

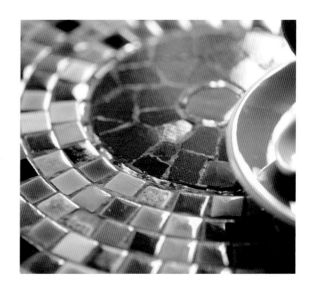

20 Glue the triangular tesserae beginning at the outer edge of the ring: glue a few triangles of the first row, then add a few triangles from the next row before going on. This will allow you to adjust the placement of the tesserae before the glue dries.

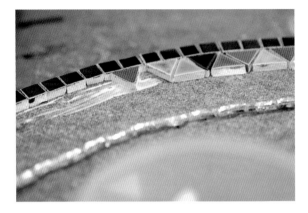

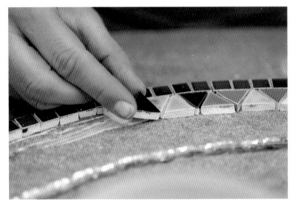

21 Cut background tesserae from red and brown ceramic to fill in the remaining areas.

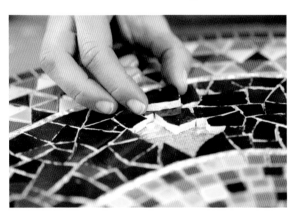

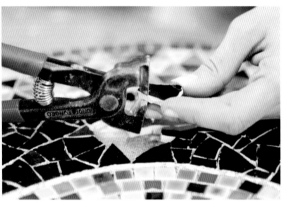

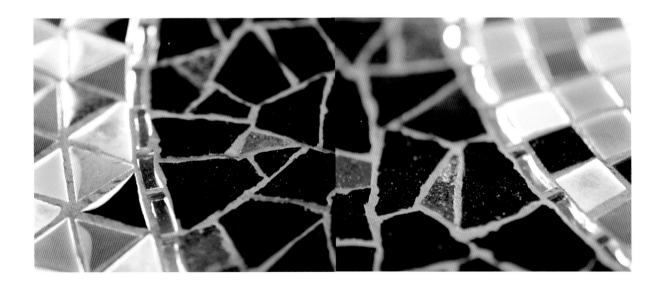

22 Cover your work surface; then prepare some black grout. Apply it all over the table top, removing the excess with your finger.

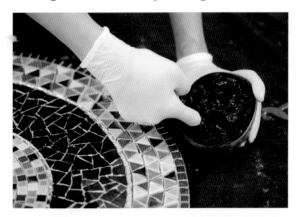

24 Apply the grout to the edges of the table in the same way.

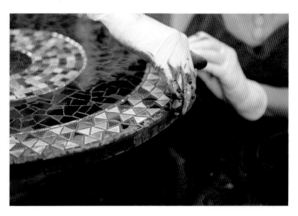

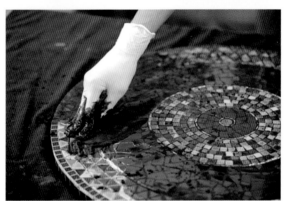

25 Rub and clean with a dry cloth.

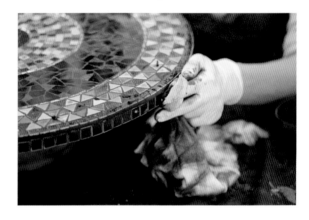

23 Rub and clean with a dry cloth.

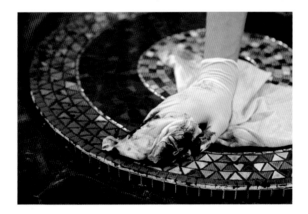

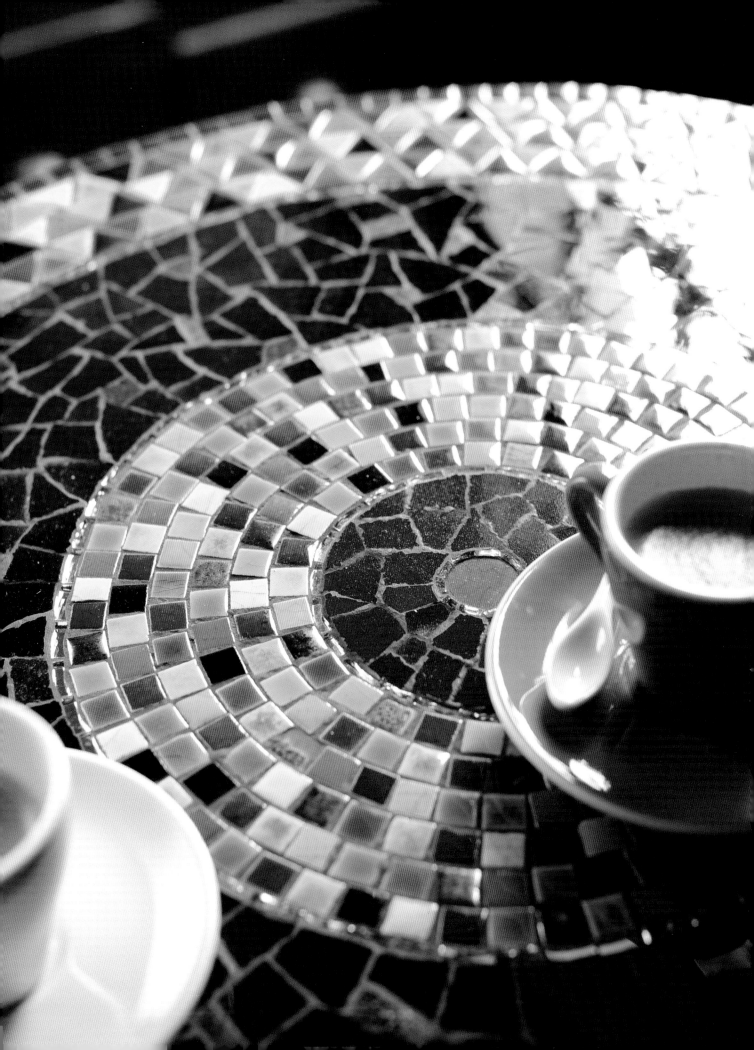

03

Springtime mirror

This composition is completely manageable for a beginner, but it takes patience to cover the whole frame. Don't hesitate to adapt the floral design for a smaller surface to start.

Materials

- Pink, red, yellow, orange, light green, and medium green ceramic
- 13 ¾" x 20 ⅞" (35 x 53cm) mirror
- Particleboard, ⅜" (10mm) and ⅝" (16mm) thick
- Flat-sided molding, ⅜" (10mm) and 1" (26mm) wide

Tools

- Tile nipper
- Mosaic glass cutter
- Tile scorer
- Glass cutter
- Scissors
- Backsaw
- Miter box
- Nails
- Hammer
- Drawing square
- Tape
- White paper
- Carbon paper
- Felt-tip pen
- Pencil
- Patterns, page 62
- Cloth
- Sponge
- Assorted containers
- Latex gloves
- Brush for glue

Adhesives

- Mirror glue
- Wood glue
- Black and white grout

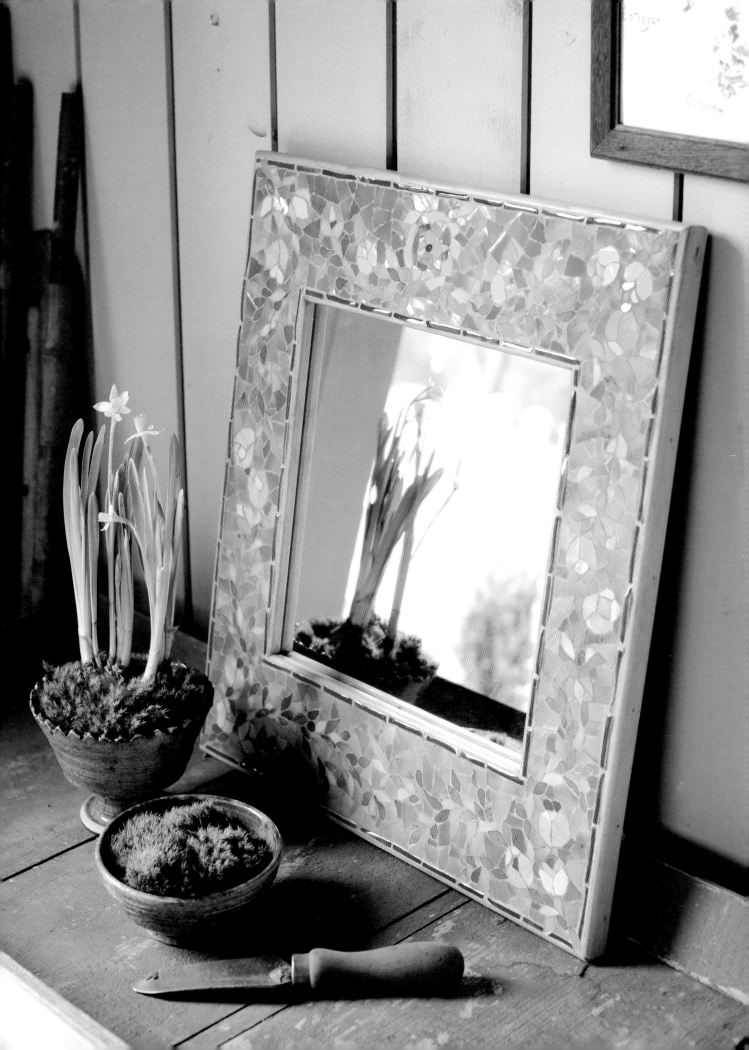

1 Cut a 17 ¾" x 25 ⅝" (45 x 65cm) rectangle from the ⅝" (16mm) particleboard for the backing. Cut two 2" x 25 ⅝" (5 x 65cm) and two 2 ⅜" x 13 ¾" (6 x 35cm) rectangles from the ⅜" (10mm) particleboard for the frame.

2 Pencil guide points on the backing to center the mirror. Fasten the mirror with the mirror glue.

3 Trace the design pattern on the framing boards with the carbon paper (see page 13).

4 Apply wood glue to the framing boards and attach them around the mirror: Begin with a long side, then position the top and bottom, then the final side. Make sure you have the boards correctly positioned before the glue dries.

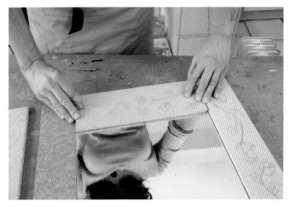

5 Reinforce the frame with a few nails.

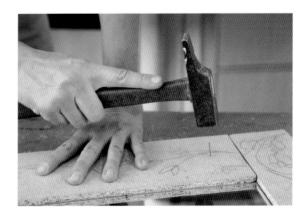

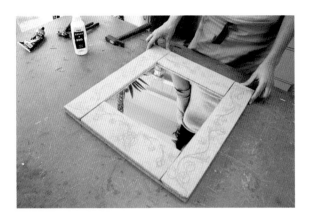

8 Glue and nail the outside moldings (the wider ones) so they stick out ¼" (5mm) on the mosaic side.

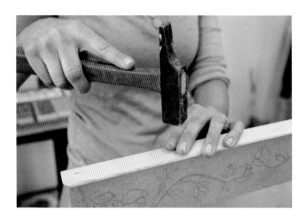

6 Make sure the overhang of the flat molding corresponds to the thickness of the ceramic tesserae. Here, the overhang is ¼" (5mm).

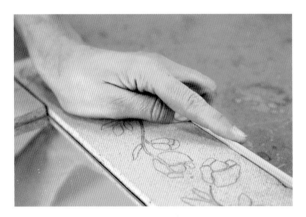

7 Cut the molding on the diagonal with a back-saw and a miter box.

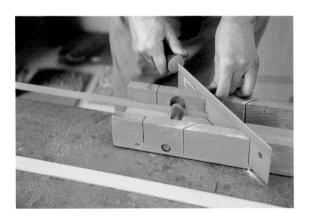

9 Glue the inside moldings, slipping a sheet of paper underneath to avoid getting any glue on the mirror. Don't use nails; these moldings are so narrow you might damage the mirror.

10 Number each flower petal on the pattern and on the frame.

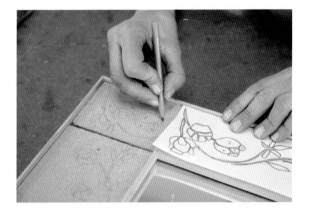

11 Cut out the petals one by one.

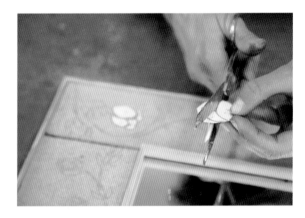

12 Trace the shape of each petal on the ceramic times with a felt-tip pen.

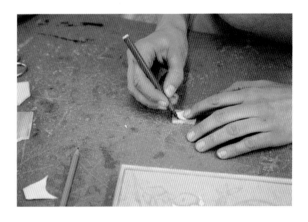

13 Cut out each petal with the mosaic glass cutter.

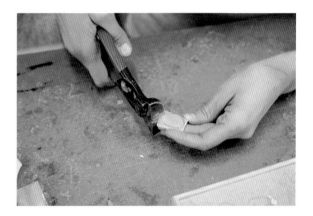

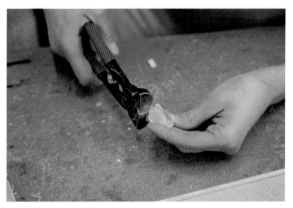

14 For concave shapes, nibble with the mosaic glass cutter.

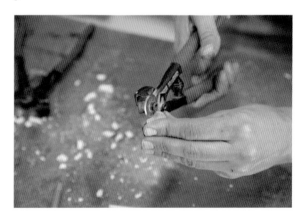

TIP
Tracing the design on the ceramic is reliable, but time-consuming. You may also cut the petals free form if you don't mind slightly modifying the original design.

15 Proceed in the same way for the leaves. Prepare a large quantity before you begin gluing.

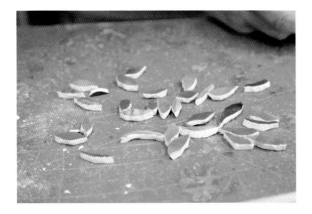

16 Using wood glue, glue the flowers and leaves, one at a time.

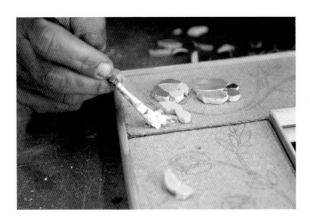

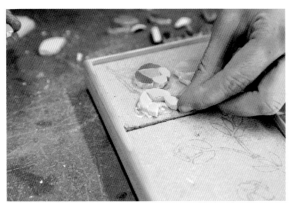

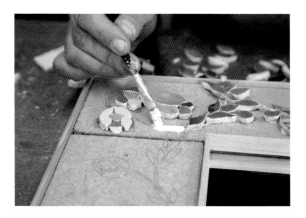

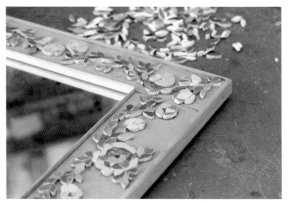

17 The frame line is emphasized with narrow pink borders. To get regular segments, trace guide points with a felt-tip pen every ¼" (5mm) on a ceramic tile.

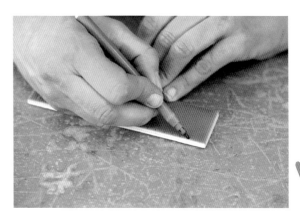

18 Use the drawing square and the tile scorer to mark lines according to these guide points.

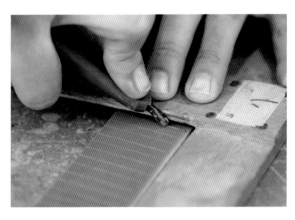

19 Separate the strips by pairs using the glass cutter.

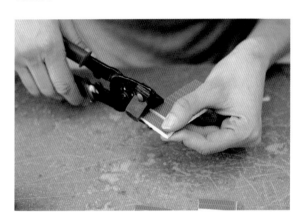

20 Separate the pairs.

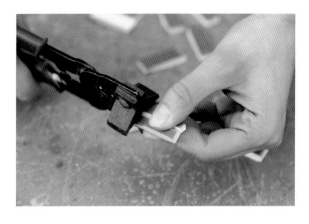

21 Glue the borders with wood glue.

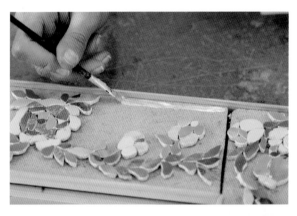

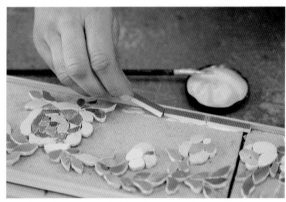

Industrial ceramic tile will give you perfectly regular segments of the desired thickness. If you use handmade ceramic, as we do here, the borders will not be as thick. It will be necessary to raise them by using tiling mortar, then remove the excess mortar with a knife.

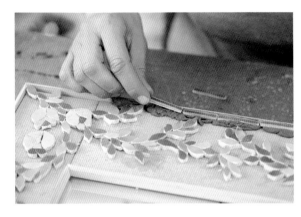

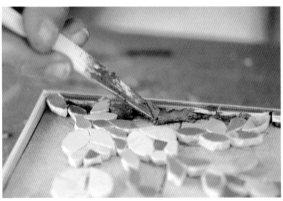

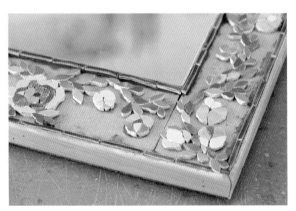

22 Cut the background tesserae with the tile nipper. Size them according to the spaces they must fill.

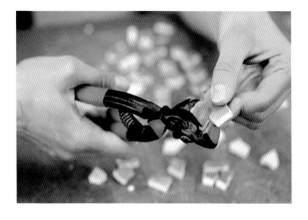

23 Begin by gluing the background tesserae along the inside and outside edges.

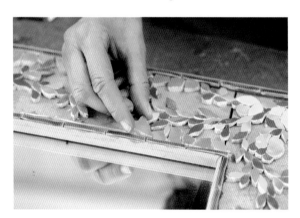

24 Then fill in the remaining space.

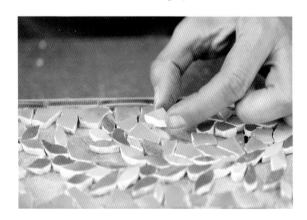

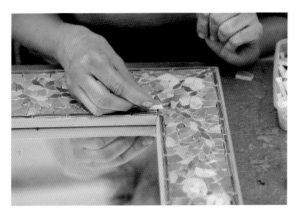

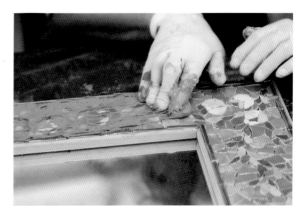

26 Apply the grout, removing the excess with your finger.

TIP

As much as possible, keep the interstices thin and even, so the design won't be marred by a too-thick grout line.

27 Rub and clean with a dry cloth. If the grout has dried too quickly, dampen the cloth a little. Clean the wooden moldings with a very lightly dampened sponge. Let dry.

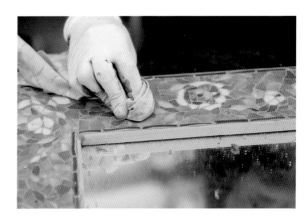

25 Prepare a light gray grout by mixing white, black, and water.
You may also buy pre-mixed gray grout.

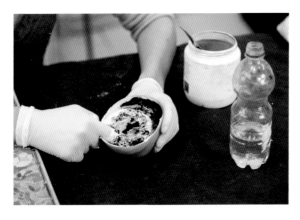

42

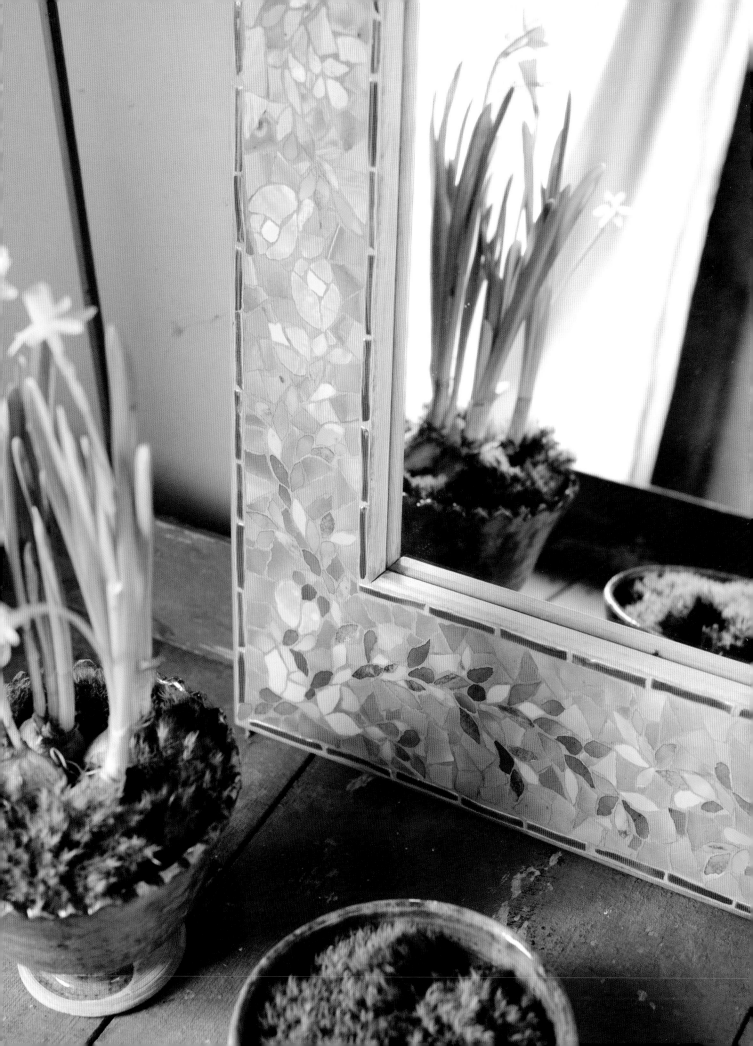

Frosted decoration

This mosaic, with its cool, aquatic hues, is perfect for a bathroom. Thanks to the indirect method, you can insert a decorative square in a tiled wall, or outline your walls with a delicate frieze.

Materials

- Green and blue speckled ceramic tile
- Ceramic tile (template)
- Mirror

Tools

- Mosaic glass cutter
- Tile nipper
- Pencil
- Scissors
- Felt-tip pen
- Paper
- Transparent plastic
- Tape
- Plastic knife
- Assorted containers
- Latex gloves
- Brush for glue
- Fiberglass mesh

Adhesives

- Wood glue
- Tiling mortar
- Gray grout

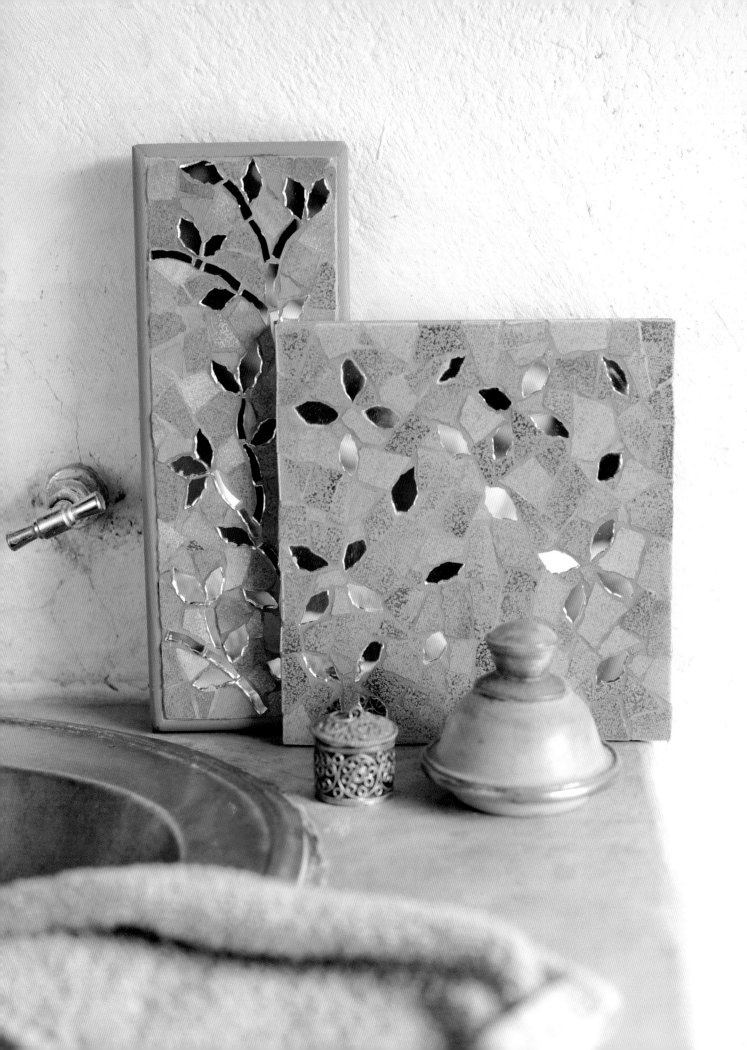

1 Put the template tile on a sheet of paper and trace it. Cut it out. Do the same thing on the fiberglass mesh.

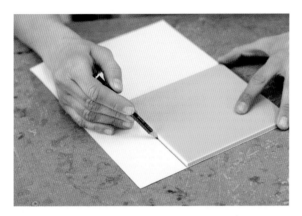

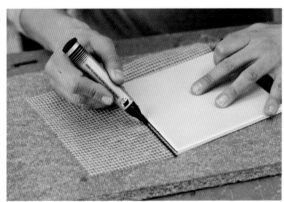

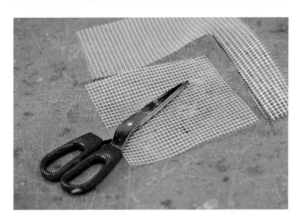

2 Draw the design with the felt-tip pen on the paper.

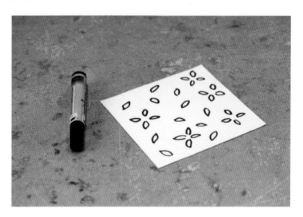

3 Put transparent plastic on the square of paper to keep the mosaic from sticking. Put the mesh on top and tape everything to the table.

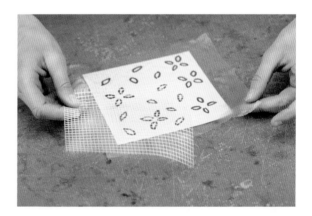

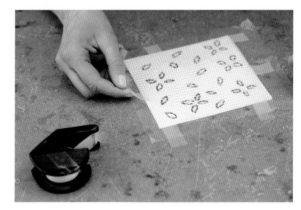

4 Cut out a few mirror petals with the mosaic glass cutter.

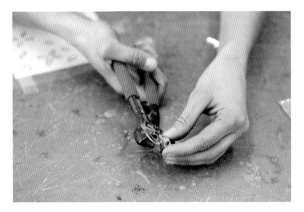

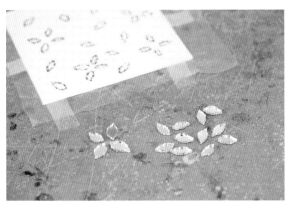

5 Put a little wood glue in a container and dilute it slightly with water.

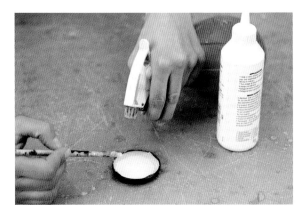

6 Using a brush, attach the petals to the mesh, using as little glue as possible. The glue will harden more slowly than on wood.

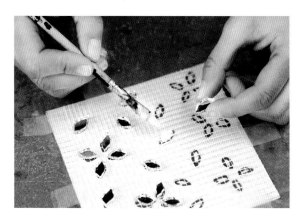

7 Cut the background tesserae with the tile nipper. Position them, starting with the edges, then fill in. To make sure the edges of the square are perfectly straight, cut the edge tesserae from the straight edges of the tile.

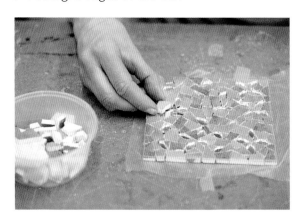

8 Put tiling mortar on the back of the square.

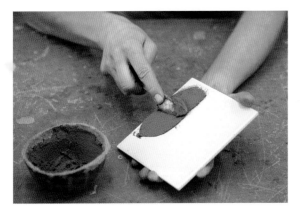

TIP

If your mosaic is going on a wall, apply the mortar directly to the wall.

9 Press hard on the mosaic assembly to ensure a flat surface. Let the mortar dry a few hours.

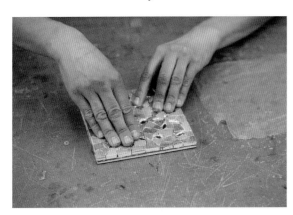

TIP

If the mortar runs over, remove the excess with a sponge.

10 Apply gray grout to the whole surface, including the edges.

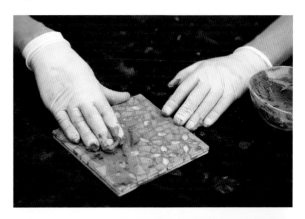

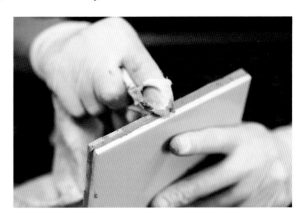

11 Clean with a dry cloth.

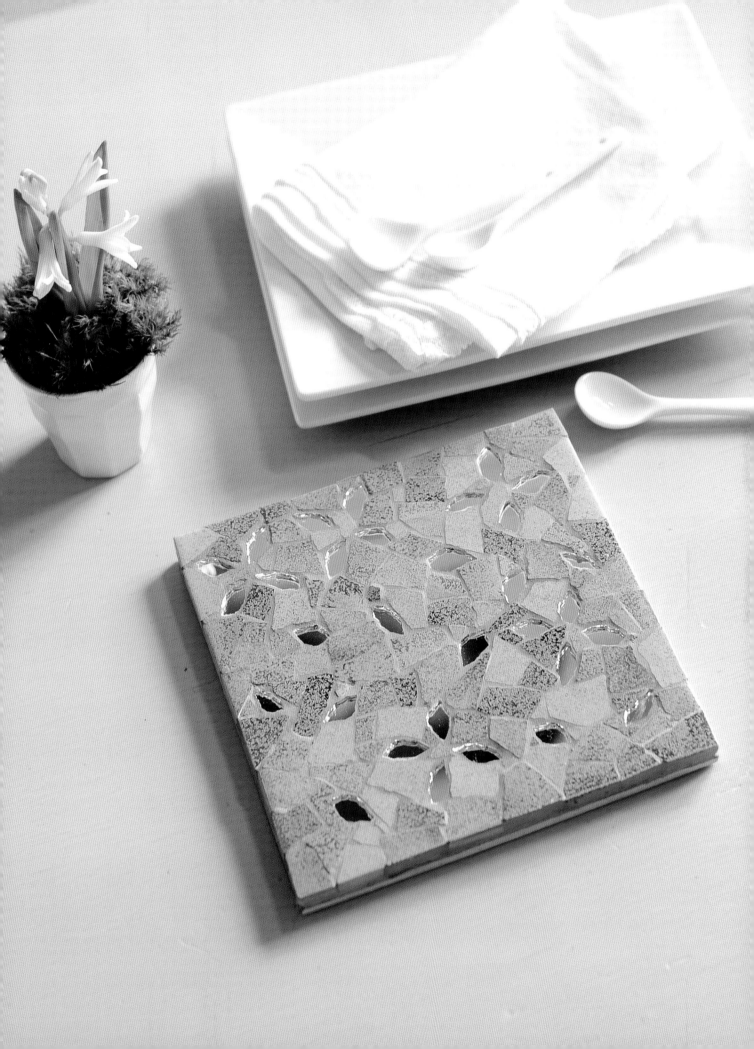

Mosaics
by Alexandra Carron

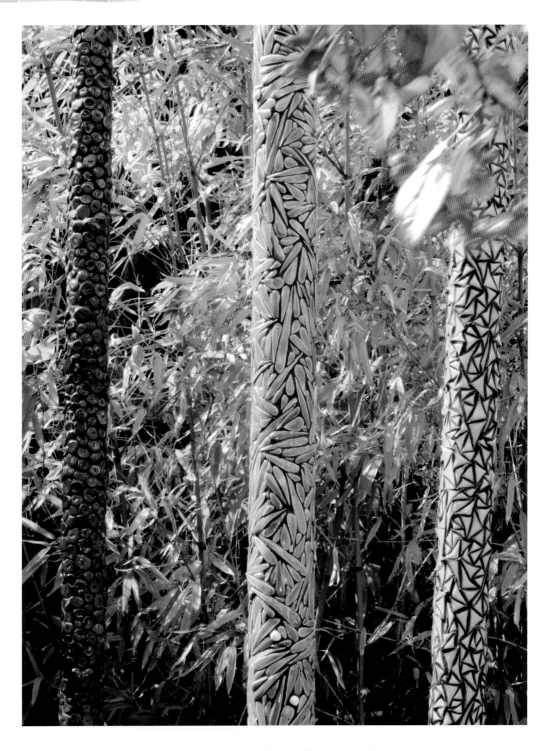

Wild Grass, sculptures, ceramic, height 8'4" (2.60m), diameter 4" (10cm)

Wild Grass

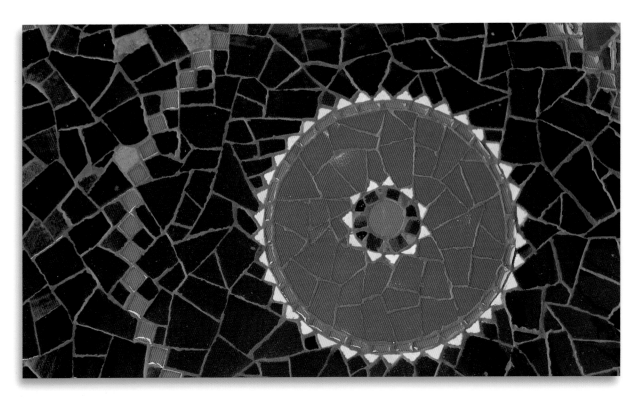

Table, ceramic and gold, diameter 31 ½" (80cm)

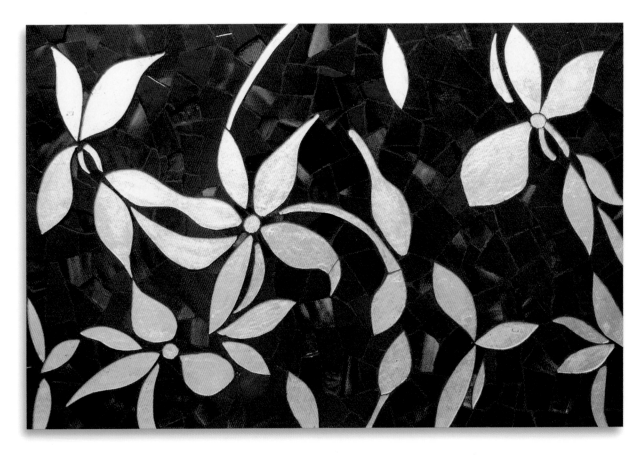

Panel, detail, ceramic and gold, 23 ⅝" x 15 ¾" (60 x 40cm)

Panel, ceramic and silver leaf, 4 ¾" x 4 ¾" (12 x 12cm)

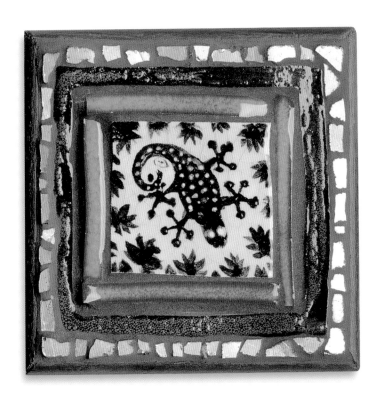

Panel, ceramic and gold, 4 ¾" x 4 ¾" (12 x 12cm)

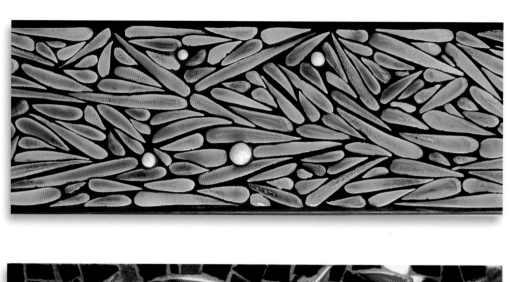

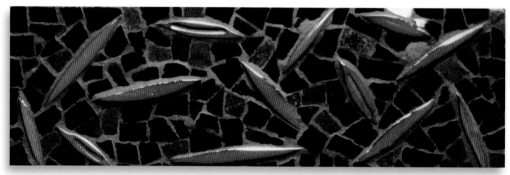

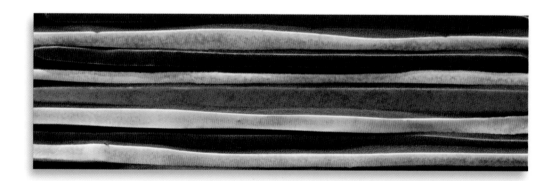

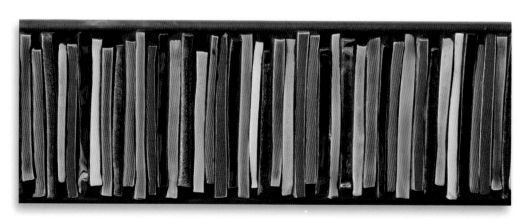

Planks, details, ceramic

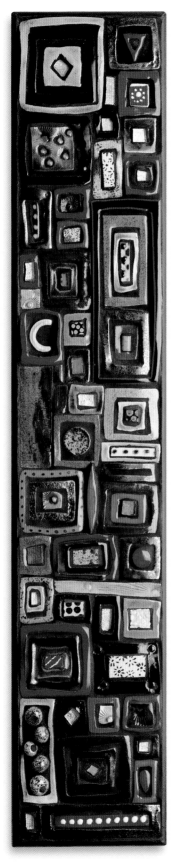

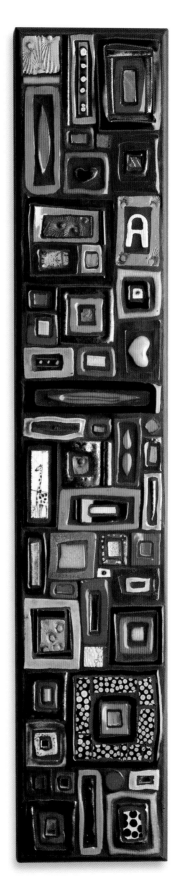

Panels, ceramic, gold, and silver, 5 ⅛" x 23 ⅝" (13 x 60cm)

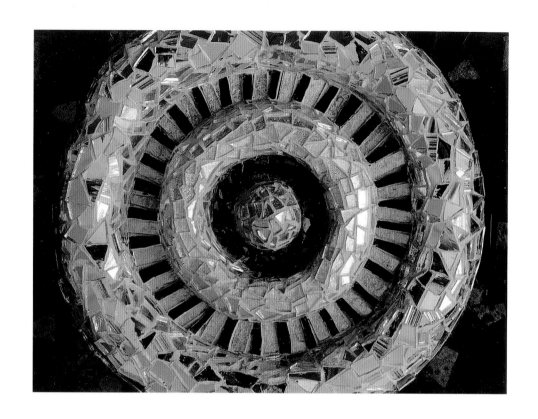

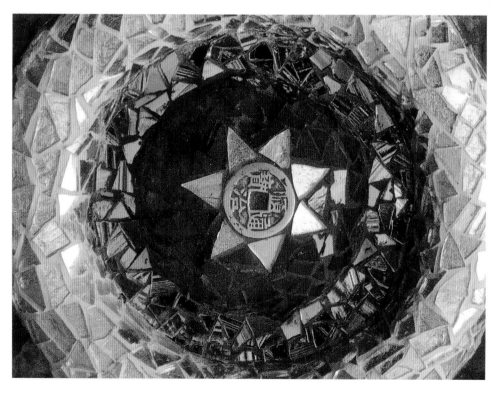

Details, ceramic, glass tile, gold, and mirror

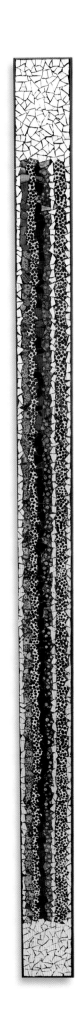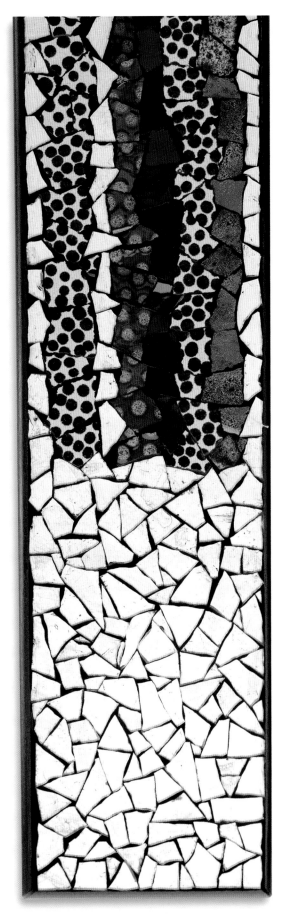

Totem (full view and detail), ceramic and gold

Mosaics by students

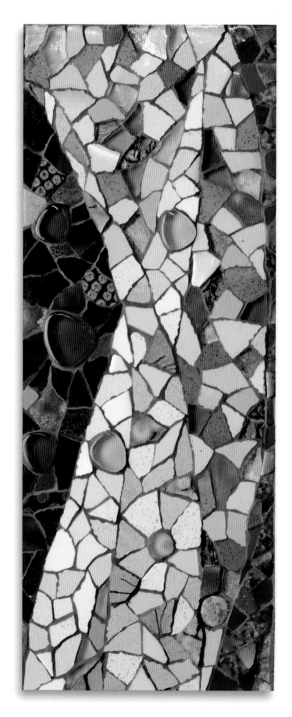

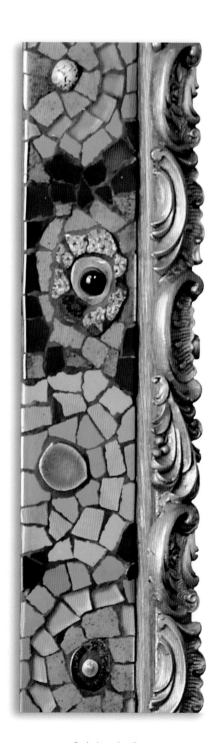

Karine Bigand

Stéphanie Cotton

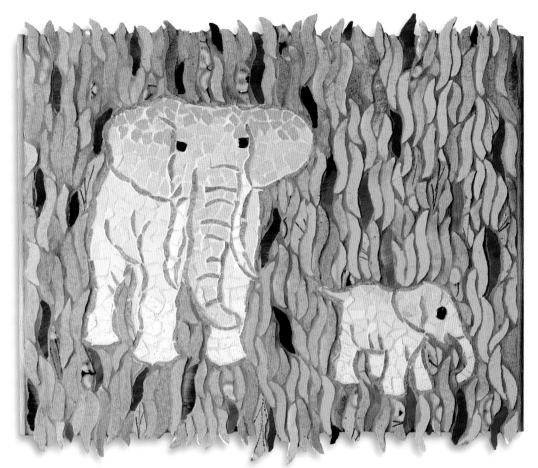

Sylvine Serman

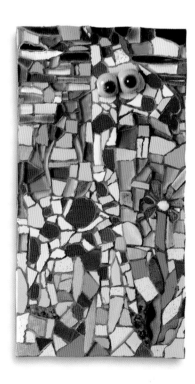

Maxence d'Audiffret

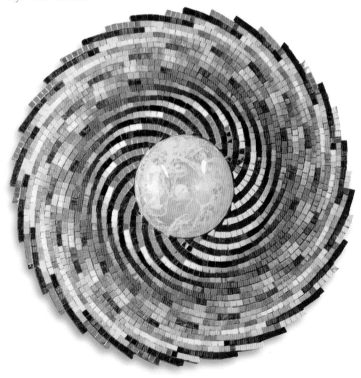

Martine Breteau

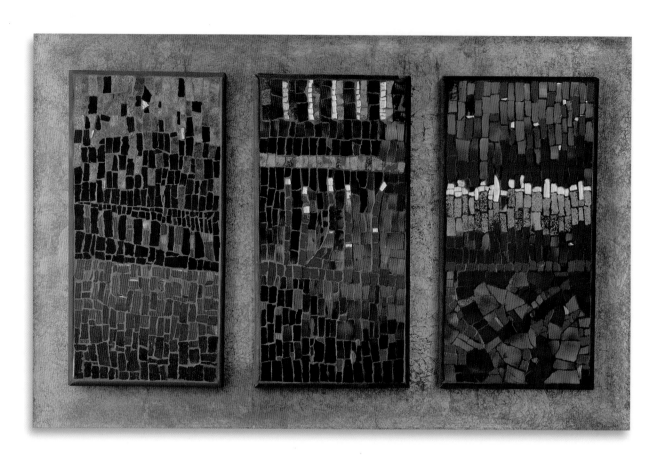

Laetitia Elbaz

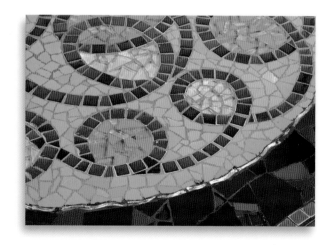

Agnès Lhullier

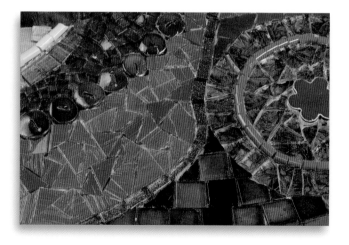

Martine Breteau

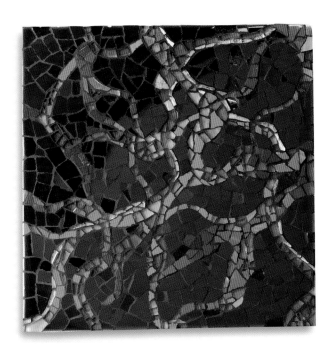

Juliette Gidon

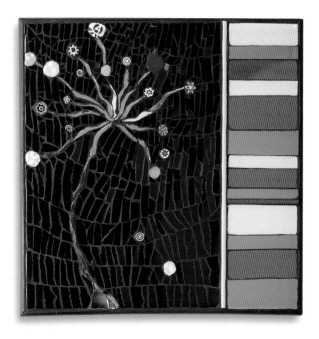

Elodie Filaquier

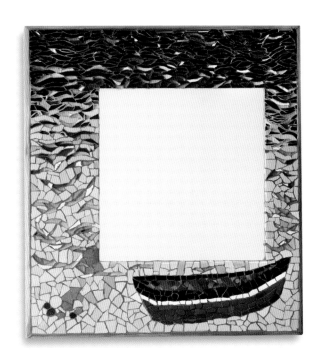

Estelle Rage

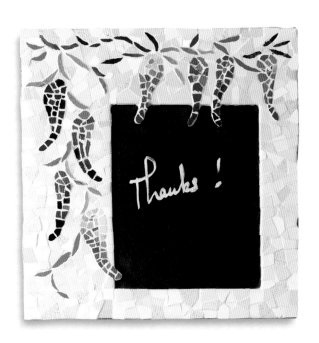

Estelle Rage

Patterns
for springtime mirror

Enlarge to 150%

Design for top

Design for bottom

Design for left side

Design for right side

From Schiffer Publishing

Other Books of Interest

Mosaic Art Today
Jeffrey B. Snyder, Editor
ISBN: 978-0-7643-4001-7
Price: $50.00

Fused Glass Mosaics: Master Class Techniques with Martin Cheek
Martin Cheek
ISBN: 978-0-7643-3933-2
Price: $34.99

The Mosaics of Louis Comfort Tiffany
Edith Crouch
ISBN: 978-0-7643-3141-1
Price: $99.99

Ceramic Art Tile for the Home
DeBorah Goletz
ISBN:0-7643-1297-9
Price: $29.95

Glass Tile Inspirations for Kitchens and Baths
Patricia Hart McMillan & Katharine Kaye McMillan, PhD
ISBN: 0-7643-2509-4
Price: $19.95

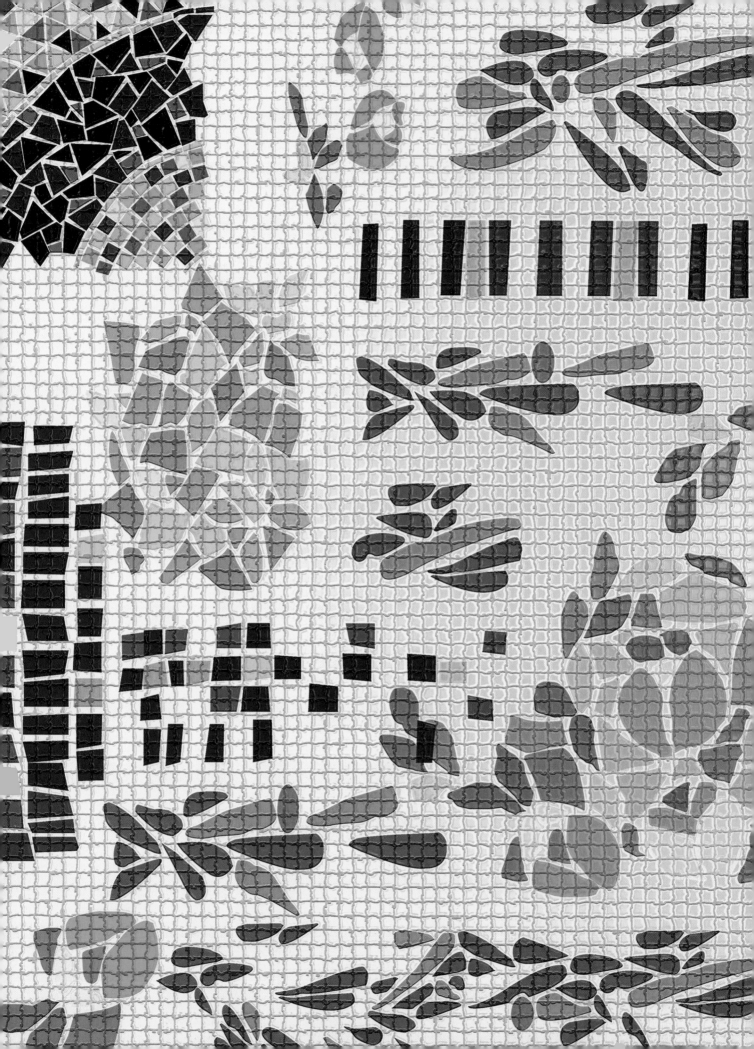